Christian Pirate

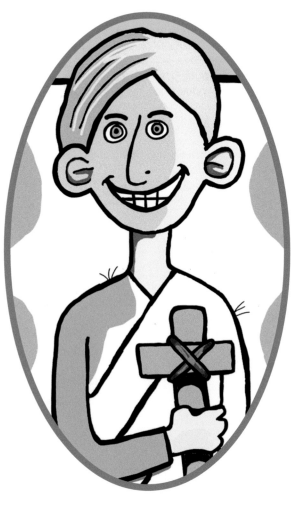

AuthorHouse™ UK
1663 Liberty Drive
Bloomington, IN 47403 USA
www.authorhouse.co.uk
Phone: 0800 047 8203 (Domestic TFN)
+44 1908 723714 (International)

ISBN: 978-1-7283-9164-9 (sc)
ISBN: 978-1-7283-9165-6 (e)

This book is printed on acid-free paper.

Print information available on the last page.

Published by AuthorHouse 08/12/2019

authorHOUSE®

Christian Pirate

Mark-Anthony Abel

Ever wondered why there are few, if no pirates upon the seven seas?

I suppose you imagine a fierce battle had brought them to their knees.

If you listen carefully, I'll tell you what I know,

Of one so full of greed and one as pure as snow.

Once upon a time, some hundred years ago,

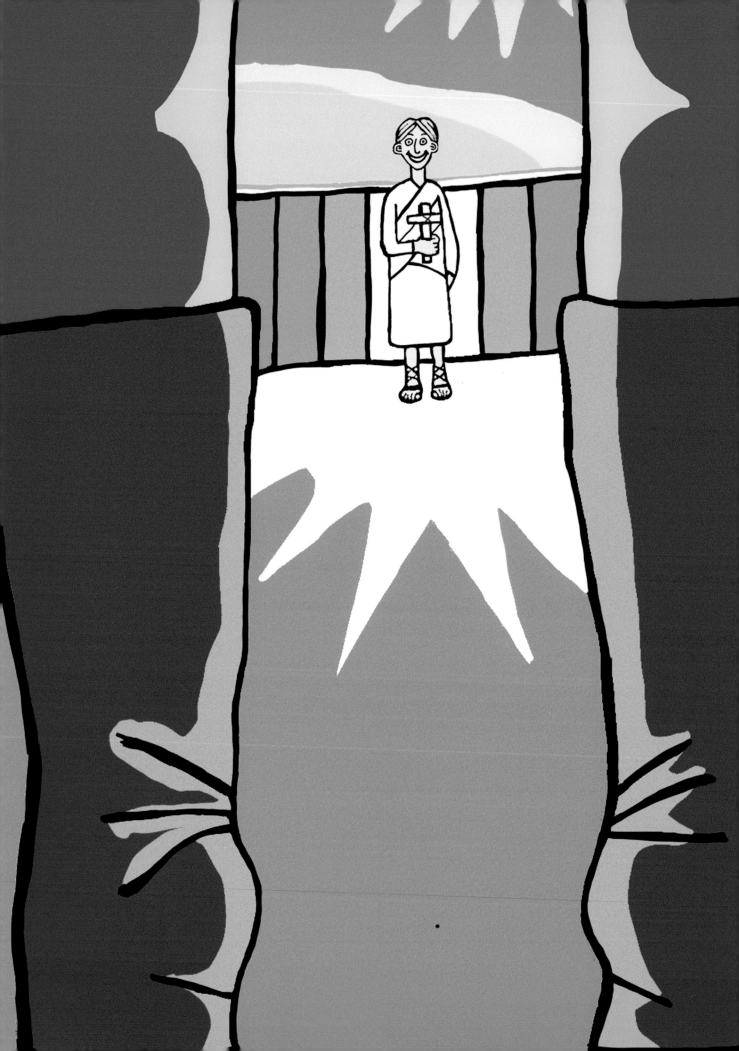

A Christian Pirate came across one you ought to know.

Dreaded Blackbeard was the plunderer of the seas.

He terrorized the oceans and brought countries to their knees.

The most feared pirate of all with many cannons on his ship

And a menacing cutlass that dangled from his hip.

Most would take fright and rather walk the plank.

Yet the Christian Pirate climbed aboard as
the ship moored by the bank.

As the boat to'd and fro'd, most landlubbers would be sick.

I'd heard our Christian Pirate had befriended Moby Dick

But what could protect him from Blackbeard and his crew?

Dressed in sackcloth and worn sandals there
seemed nothing he could do.

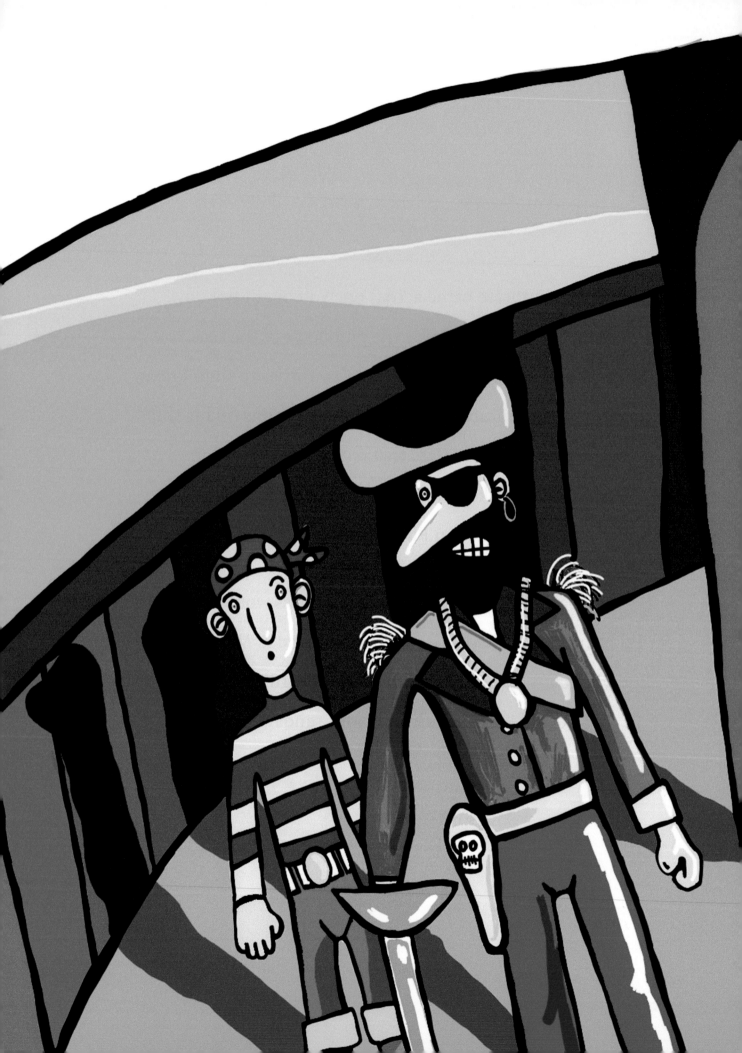

"Who are you?" asked Blackbeard, his dark eyes blinking.

There was something about this man that really had him thinking.

The man, who we'll call Chris, smiled and then he said:

"I am a simple Pirate", then gently bowed his head.

Blackbeard and his crew let out a roar of laughter.

If you'd seen what they all saw, you might have laughed soon after.

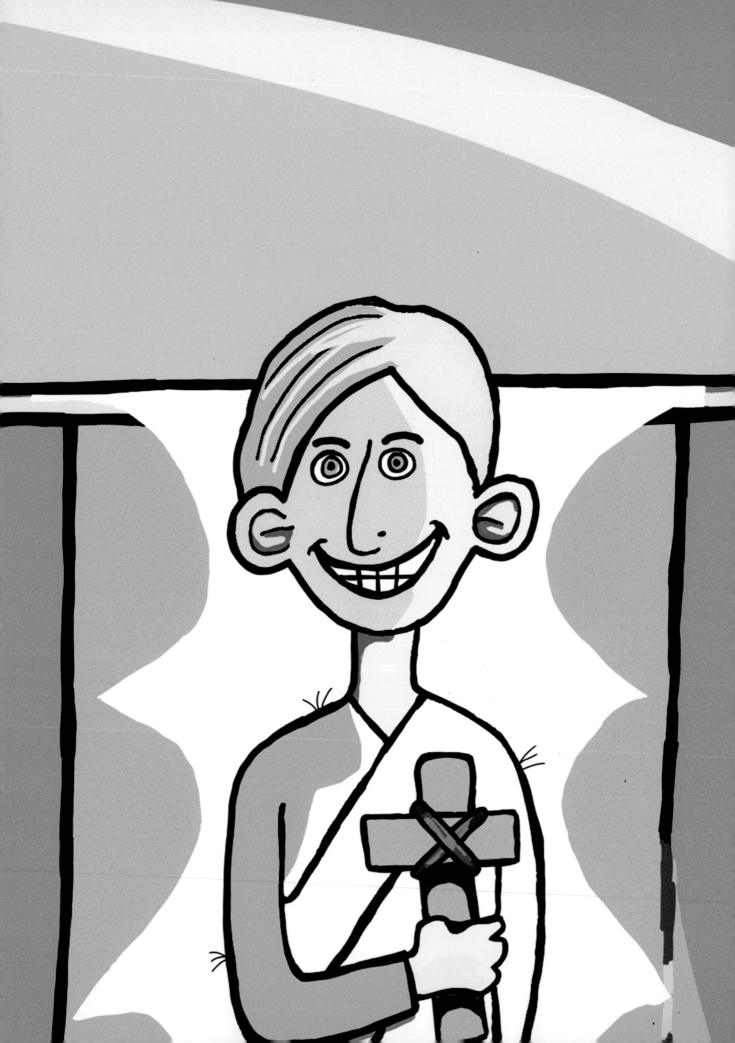

"You, a pirate? They laughed. You look more like a beggar!

If you are a pirate, then show us all your treasure."

"Treasure?' said Chris. "I have nothing to declare,

Except a map to the greatest treasure, should any of you dare."

"The greatest treasure?' said a pirate, calm and bold.

'Yes' said Chris. 'Better than a mountain of gold."

"What is this treasure? Blackbeard crossly said.

'It sounds strangely fishy and messes with my head!"

"I have a compass to find it, made of two pieces of wood.

The prize is everlasting life and a whole lotta good."

'Woah', said the men, yet Blackbeard merely groaned.

Some listened intently whilst other men moaned.

"If you are a pirate, what battles have you fought?

Anything more than a sniffling cold you have caught?"

"I have fought the greatest battle, but some may not agree;

The greatest battle I have fought is the one I had with me.

Some of us fight for love and some fight for fame,

Some of us fight for worldly things or for some other gain.

From the trials of my life, I have now understood,

That the hardest battle in this world is the battle to be good."

The men's mouths opened and they started to agree;

They looked upon Chris as a way to be free.

A way to escape the inside of a ship;

Scrubbing and toiling on every long trip.

They had used their cutlasses and shot their guns,

Yet with pockets of gold their hearts had grown numb.

Fighting themselves was a battle indeed,

And the more that they fought, the more they did need.

"All pirates have a captain, is yours more famed than me?

Tell me the truth, Chris, or be thrown in the sea!

Tell 'em his name as imposters aren't welcome.

And I want you off my ship 'fore ye start a rebellion."

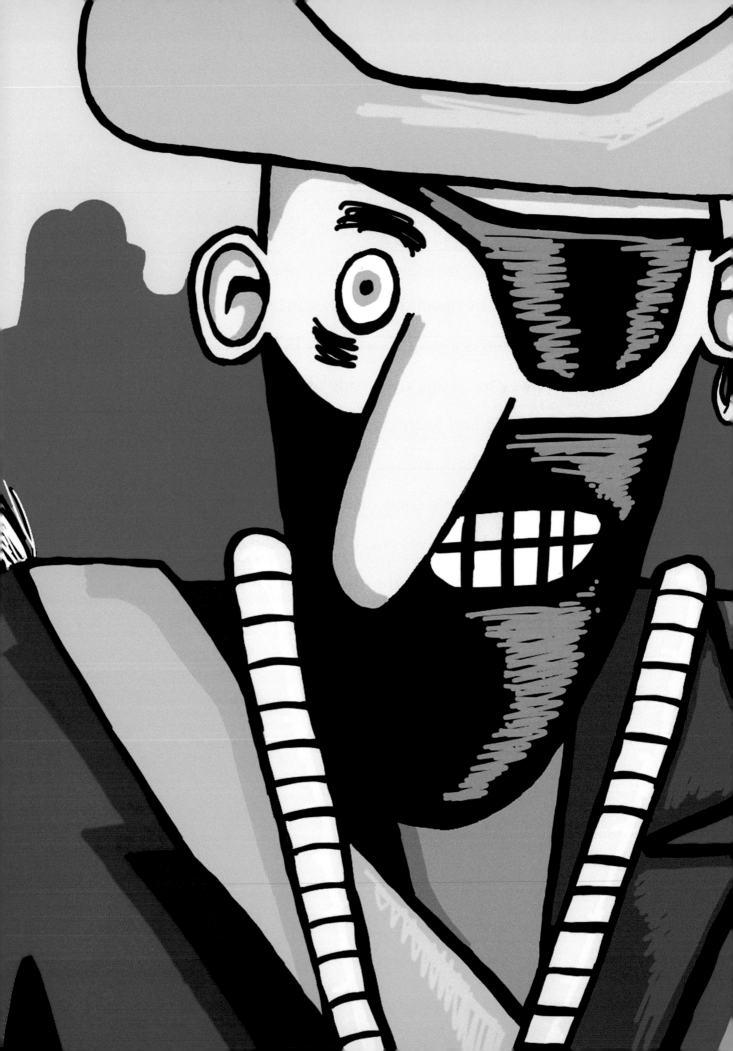

Blackbeard now feared this lonesome stranger,

How could one man pose so much danger?

The pirates now looked extremely confused.

Were they witnessing a battle their captain might lose?

"My captain is Christ, do you not yet see?

He gave his life for you, both shackled and free.

With no weapon in his hand he has slayed these seas,

And brought kings and queens down to their knees."

"He gave his life? That don't sound very smart!

I fight with my sword and not with my heart.

When I shoot my cannon I can destroy a whole galley,

And my name is whispered in every dark alley."

But the men were not moved by the words of their captain,

Though he boasted and vexed, it was Chris that now grabbed them.

"He gave his life for his men? What a noble thing!

Pirates don't seem to care about their own brethren.

So what is your name, please tell us the truth,

We think we've heard of you but give us the proof."

"I am the Christian Pirate, the most feared pirate of all,

And not even Blackbeard can stand up to my gall.

Be you a pirate or a lost soul at sea,

I know the perfect way that you can be free.

I have fought for my captain and I will do it again,

For he gave his life, gave his life for his men.

Do not be afraid, but do follow me,

For God's treasure is boundless, just come and you'll see."

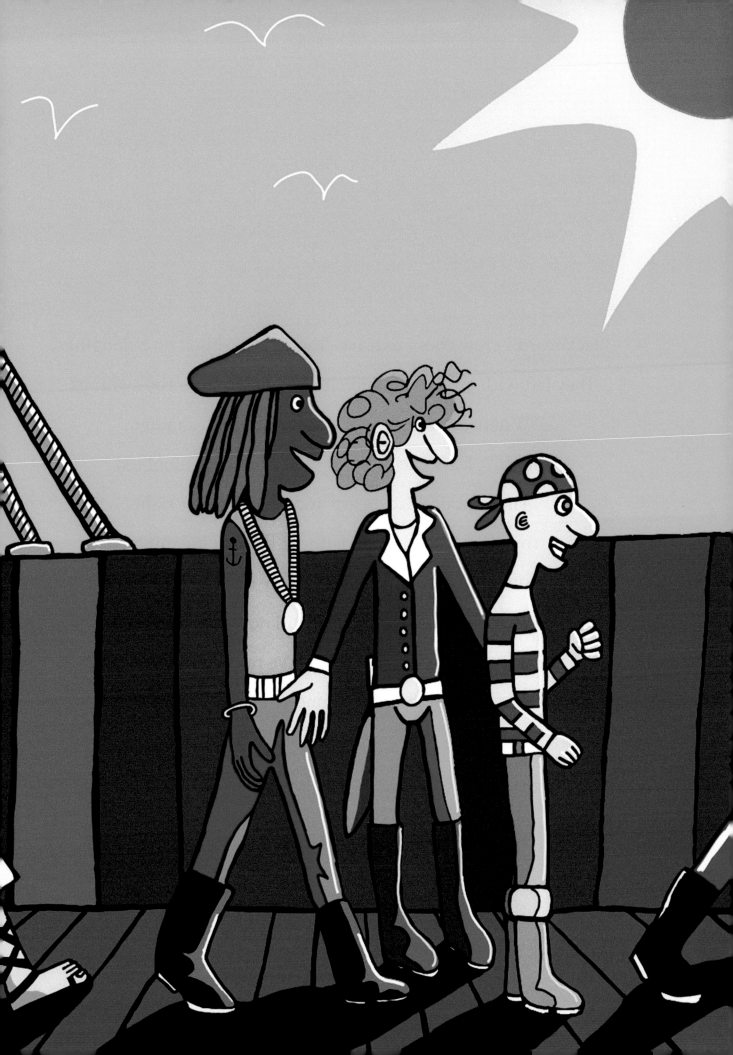

Blackbeard's crew chose to leave. Though they took no belongings,

They left with great hope and climbed down from the awnings.

"Where are you going?' Blackbeard then shouted,

'You can't leave the ship lest your honour be doubted."

"I'm Captain Blackbeard and this just ain't right.

You can't take my men without beating my might.

You can't take my men till you're black and blue,

Even then, if you win, they'll still not leave with you,

We've crossed seven seas and we've ransacked them all,

I won't give them up to one so pitifully small."

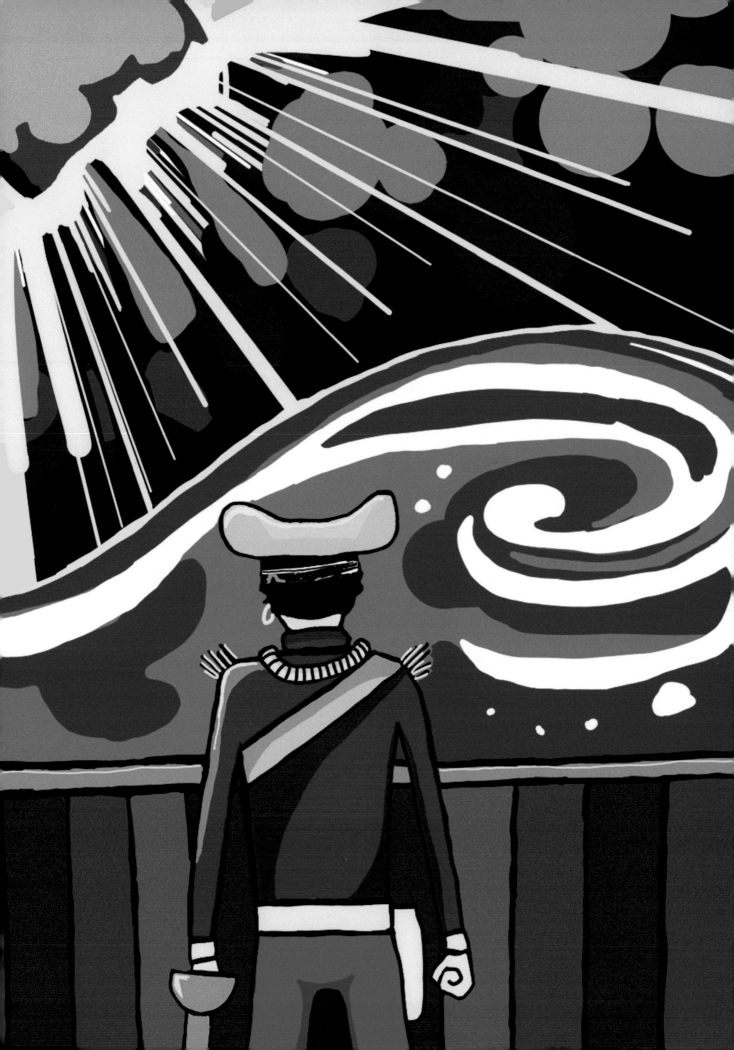

Then the clouds grew black and the waves rose high,

And the Christian Pirate looked up at the sky.

"Blackbeard", shouted Chris. "This won't be a fair fight,

My God will not stop till he has done what's right.

He will summon the wind and he'll summon the sea,

Your ship will be sunk if you won't let us go free."

"Go ye then, said Blackbeard, but come here no more,

I can see when a battle's not worth fighting for.

But how can your words be stronger than steel?

Why do your words have so much appeal?"

Blackbeard sat thoughtfully, as captains before him,

He knew this was a fight that he could not win.

The stories had run from the North to the South,

But Blackbeard now heard it from Chris' own mouth.

For pirates use fear to weaken mere folk,

But Chris was too strong and it was Blackbeard that broke.

Though it was also Blackbeard that Chris had come to save,

It was physical treasure that Blackbeard still craved.

As much as he grumbled and as much as Chris pleaded,

It was when love was discussed that Blackbeard then yielded.

Chris spoke of how Jesus had died on the cross,

Then Blackbeard's eyes welled up as he imagined the loss.

He would never have given his life for his crew,

But now here was his chance to do some good too.

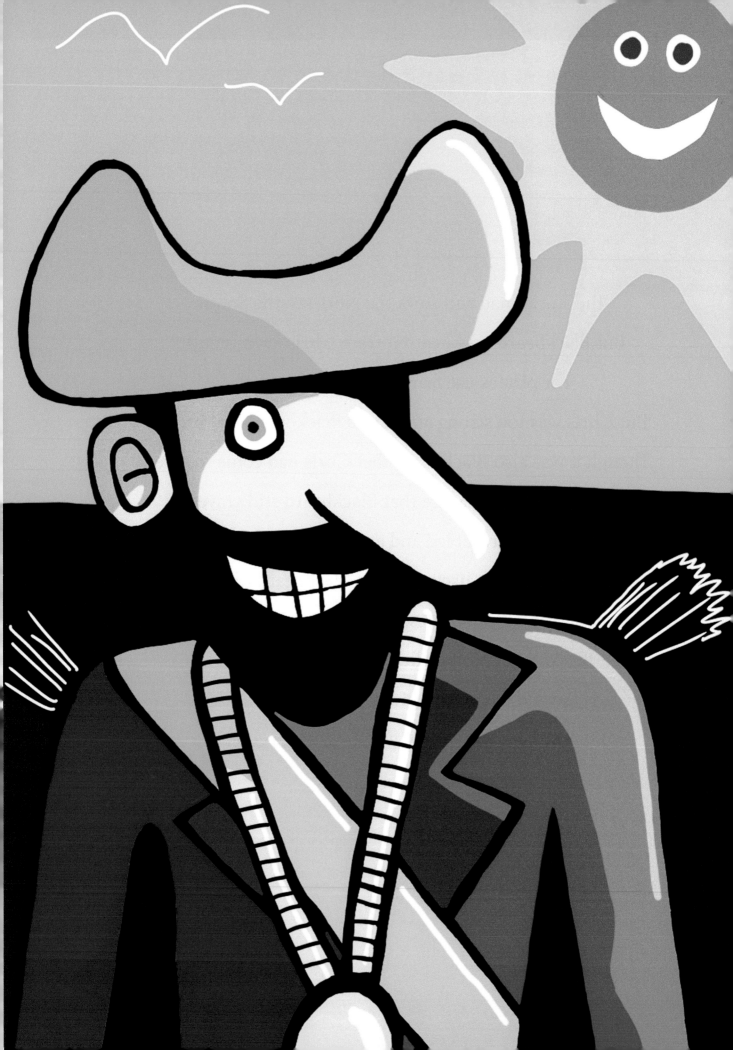

"Please let me join you and in all manner of weather.

Let's sail these seas. Let's do this together."

So this is why fewer, if no, pirates exist.

It is because of the bravery of a pirate called "Chris."

And they sing:

"He is the Christian Pirate, I will hear you say it again.

As captains plunder ships for treasure,

He plunders ships for men.

They fear him on the sea,

They fear him on the ocean.

As captains plunder ships for treasure.

He plunders ships for men."

Printed in the United States
By Bookmasters